MW00564868

THIS NOTEBOOK BELONGS TO ..

CONTACT ..

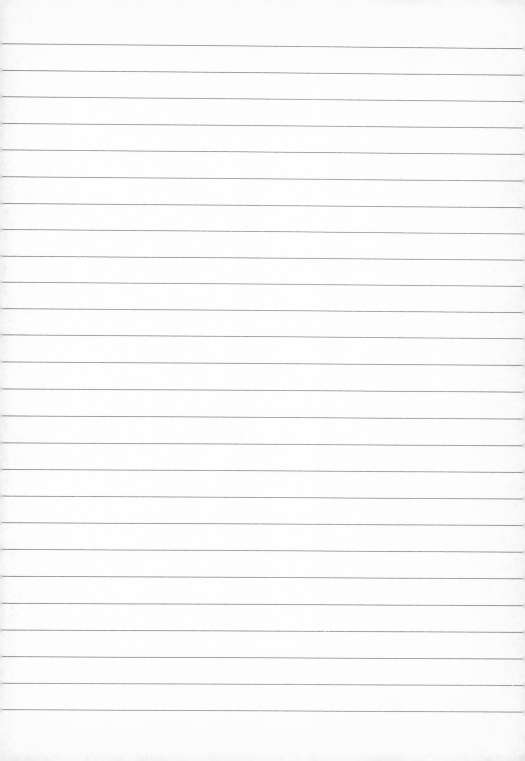

See our range of fine, illustrated books, ebooks, notebooks and art calendars:
www.flametreepublishing.com

This is a **FLAME TREE NOTEBOOK**
Published and © copyright 2017 Flame Tree Publishing Ltd

FTNB 63 • ISBN 978-1-78361-344-1

Cover image based on
The Scream, 1893 by Edvard Munch (1863–1944)
Courtesy of Wikipedia/User: The Herald/Public Domain

Munch's most famous painting exemplifies Norwegian Expressionism.
The angst-ridden human condition has never been so superbly and unassailably
conveyed as by this figure emitting a cry from the heart. Life, love and death are
the themes which Munch endlessly explored in his paintings.

FLAME TREE PUBLISHING I The Art of Fine Gifts
6 Melbray Mews, London SW6 3NS, United Kingdom